MR. EAVES AND HIS MAGIC CAMERA

Farrell Eaves
with Cindy Cashman

Andrews McMeel
Publishing

Kansas City

Book design by Pete Lippincott

ISBN: 0-7407-3322-2

Library of Congress Control Number: 2002111557

Dedicated to Bruce Dale,

*whose guidance, support, and friendship helped
bring the magic camera to life*

Acknowledgments

I WOULD LIKE TO THANK BRUCE AND JOYCE DALE for first recognizing the unique beauty brought to life through the lens of the magic camera. Their ongoing support has been of great comfort. They helped me through the myriad of phone calls and e-mails and let me focus on my objectives and art. I would also like to thank Cindy Cashman for all of her hard work and energy in giving this book form and substance. I gratefully acknowledge Dorothy O'Brien and all the staff at Andrews McMeel Publishing for their enthusiasm and expertise. My heartfelt appreciation is also extended to Greg Forehand, Rick Sammon, Karen Berger, Willard Clay, David Leeseberg, Bill Sneed, Jerry Thurston, Michelle Delio, Lee Varis, Kevin Ames, and many others whose interest and encouragement fueled my desire to continue exploring the many facets of the magic camera.

Most of all, I would like to thank my family, who makes these efforts worthwhile and gives them meaning. To my wife, Fern, of forty-five years, I thank you for the joy you bring to me and for your unwavering faith in my ideas and me. Also loving thanks to my brother George for helping me put my thoughts on paper. To my daughters, Marilee and Meg, and their families, I thank you for your willing ears and for helping me navigate the pits and perils of this, my computer life. I also appreciated the unceasing support of my son,

Monte, who has walked every step in this journey with me and has been there at every turn, and his wife, Michele, for her encouragement and support. And to our Creator, who has given us this world of great beauty and the eyes and hearts to love it, my humble praise and thanks.

Foreword

I DID NOT PUSH MR. EAVES INTO THE PECOS RIVER and it wasn't my idea to tie his camera to the windshield wiper of a speeding car. All I can claim is that he is a student of mine and I did lecture him on the merits of serendipity. (I did suggest baking his camera in the New Mexico sun for eight hours followed by placing it on a gas-fired heater for another sixteen hours, which he did.)

It happened in August 2001, when Farrell Eaves ventured north into the Pecos Wilderness Area of New Mexico. At around eight thousand feet in elevation, nearing the headwaters of the famed Pecos River, he set up his tripod to capture a majestic scene.He accidentally bumped the tripod, sending it crashing into the fast-moving rapids. (The exact spot shall remain a secret as we think the salinity of the water and exact altitude is part of the magic formula.) Retrieving his camera, he retraced his footsteps back to his vehicle and returned to our Pecos River camp. After draining the camera he began his treatment. It took a couple of days—some of the steps shall remain classified, but I think it was tying the camera to the windshield wiper on the outside of the car and driving to Las Vegas, New Mexico, and back at seventy-five mph that finally dried the camera and transformed it into its magical state.

I am happy and proud to show you these pictures taken by a magical camera in the hands of a magical photographer. None of these were doctored in any way by Photoshop—they are straight out of the camera. The camera, a one of a kind, is now carefully preserved and insured (I hope) by Lloyds of London.

—Bruce Dale

Preface

I BELIEVE IN MIRACLES. I believe that there is good in everything—you just have to look for it. So when I heard about Farrell Eaves, a retired engineer, who accidentally dropped his expensive digital camera into the Pecos River and now takes "magic pictures," I could not resist meeting him and finding out more.

Instead of tossing the camera out and investing in a new one that takes pictures the way a camera ought to, Farrell was entranced by the mysterious and surreal images he saw through his lens. As he says, "Ordinary cameras see what we see; the outer shell or skin of the world around us. My camera and I peel away this covering."

To date, Farrell has shot more than fifteen thousand magical images, each one different, each one unpredictable, each one beautiful. A lot like life itself.

Who knows why Farrell's camera fell into the river that day, and who knows what happened inside that makes it do its magic. These things do not matter. What matters is that what was once ordinary is now extraordinary because a man was willing to find the good in something that seemed like nothing but an expensive accident at the time.

When I look at Farrell's photographs, several thoughts keep running through my head:

- There is beauty in everything. You just have to have the proper perspective to see it.
- If you remain flexible and open, you can take whatever life gives you and make the best out of it.
- There is so much more to life than what can be captured in a photograph.
- You are never too old to believe in miracles.

I hope you enjoy the wonderful images created by Mr. Eaves and his magic camera and that you are inspired to find the beauty and magic in your life, too.

—Cindy Cashman

Introduction

LOUIS PASTEUR SAID, "Chance favors the prepared mind." I say, chance *truly* favors the prepared mind. And sometimes, the mind and the eye need to be prepared to think differently about what we see and feel.

These truisms became clear to me in August 2001 when I was attending a Bruce Dale photography master class in Pecos, New Mexico. It was the last day of the class and I had been out taking pictures near the Pecos River, concentrating on some textures created by the swirling current acting on long strands of grass. I was intently composing an image of these interesting textures when I accidentally knocked my tripod, with a Nikon 990 digital camera firmly attached, into the water. To add insult to injury it struck a large rock during its descent and I watched helplessly as the entire assembly splashed into the water. The camera's memory card compartment snapped open in an apparent death gasp, allowing even more water to enter the delicate electronic assembly.

Crushed, I fished camera, tripod, memory card, and all, out of the water. I removed the batteries and wiped everything off with my handkerchief. Yet, despite the effort, within minutes the lens, viewfinder, monitor, control panel, and flash were completely fogged over. I resolved myself to the fact that my expensive digital camera might be

irreversibly damaged or require a costly repair. Upon returning to the conference center, I called Nikon to ask if the camera was repairable and for an estimate of the cost. They confirmed my worst suspicions: The minimum cost for repair was $300.

It's strange what one might do to avoid a $300 repair bill. Bruce Dale, class instructor and former *National Geographic* photographer, and I tried everything we could think of, using the limited resources available to us, to dry out the camera. This included blowing out the camera with canned compressed gas and placing it in the hot sun during the day and near a gas heater at night. One of the most effective, and certainly one of the most humorous, drying attempts was tying the camera to the windshield while driving around the New Mexico desert. Finally, the fogged parts of the camera cleared. The batteries and memory card were reinserted, and when the camera was switched on it came to life as if nothing unusual had happened. I took a few quick shots and the images that appeared in the camera's small monitor were not at all what I expected: They were not distorted or misshapen, but strangely discolored, revealing flowing colors that did not exist in my view of the subject. Even the most mundane and plain objects became intensely beautiful and enhanced; things such as pavement and tile floors, simple objects like plain white dishes and ordinary straight chairs magically became objects of admiration.

My heart leaped! Can this be real? Will it last? How will this camera record the things I love to photograph—churches, old buildings, and architectural details? On and on my mind raced as I mentally explored the possibilities. I was yet to learn just how unique, important and special this new photographic tool was to become.

Cloaked in my rigid expectations of what a photographic image should be, I had failed to fully appreciate these serendipitous and magnificent images, images enhanced by the rearrangement of highlights and the addition of dramatic and vividly intense spectral displays of color. Yes, the camera was truly "broken" and the images created were not the same as those seen by the unaided eye, nor could they be produced by any other camera or editing program. Instead, they were intriguing and ethereal. Simple shapes had been transformed into images enhanced by complex colors that were transfused with an impressionistic feeling.

I have been interested in photography my entire life, playing as a youngster with my Kodak Brownie, serving as a U.S. Navy photographer, taking family pictures, and documenting issues as a mechanical engineer. But now, as never before, these photographic images have aroused an awareness of the mystic beauty everywhere that awaits an introduction to my magic camera.

I create the composition and my camera responds by portraying beauty that I cannot see. In this sense I often wonder if perhaps the camera is actually composing me.

To experiment artfully and let this *broken* camera assist me in a new way of seeing is a source of true happiness. I continue to experiment with the camera almost every day, learning anew just how the interaction of light and shapes best portray the special characteristics of the limitless subjects around me in order that I might render a pleasing composition as seen through the lens of the magic camera. Most often I photograph alone, and the images I create speak in silence to the very core of my being.

Thus, herein lies the true story of *Mr. Eaves and His Magic Camera*, through it lies an enrichment of life, and in it lies a renewal of spiritual awareness and stewardship. Herein also is a wonderful lesson: When we expect our existence to be ordered in a certain predetermined way, we may miss the beauty, the originality, the simplicity, and the spontaneity of the world around us. I had to open my mind and photographic eye to the interpretations of this special camera and I have been richly rewarded by the joy resulting from having a totally new perspective.

Perhaps you, too, will discover the wonder of seeing in a new way, as I have, and realize that, indeed, beauty may be born from accidents,

misfortunes, or even tragedies in our own lives. Perhaps this gives us just a little more hope as we contemplate this complex and often harsh world in which we live. After all, is this not the *real* magic of living?

My goal is to share my excitement and wonder with you. As you view these images, try to rethink your way of seeing and allow yourself to experience the subjects with childlike wonder. It is to this end that I will always endeavor to maintain the highest level of excellence in my work, so that I can simply present, in a different light, that which has always been the same.

—*Farrell Eaves*

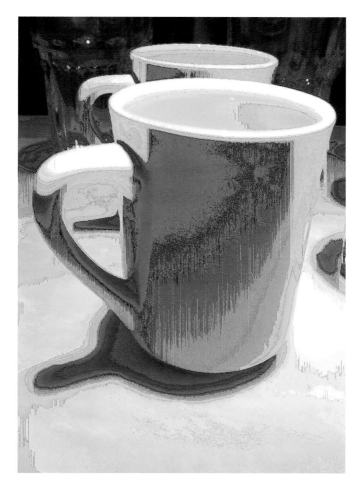

White Coffee Cups • *Pecos, New Mexico*

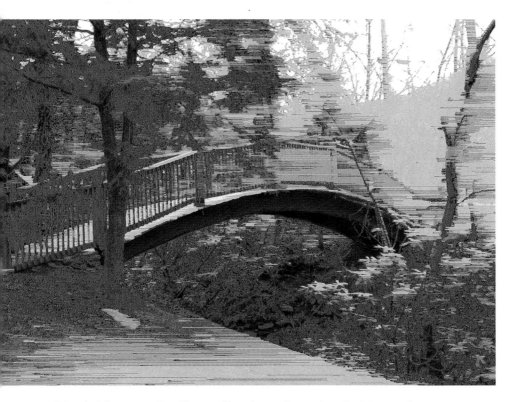

Footbridge over Le Conte Creek • *Great Smoky Mountains National Park, Tennessee*

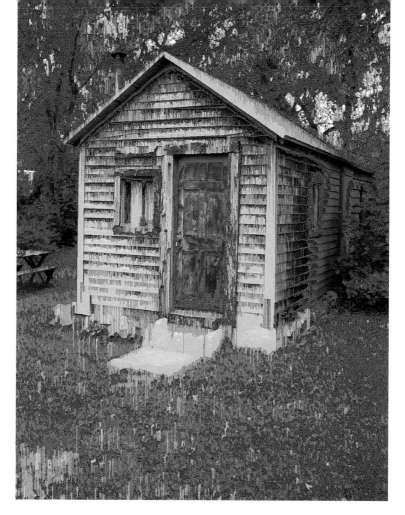

Pecos River Cabin · *Pecos, New Mexico*

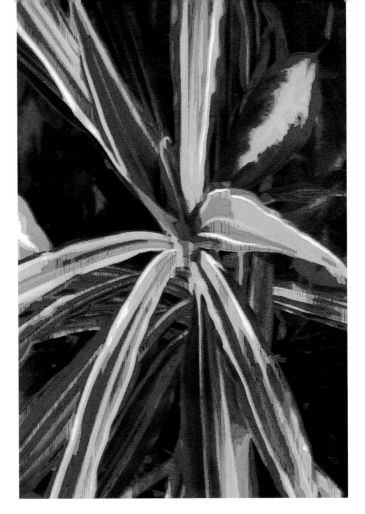

Plant Leaves • *Walden, Tennessee*

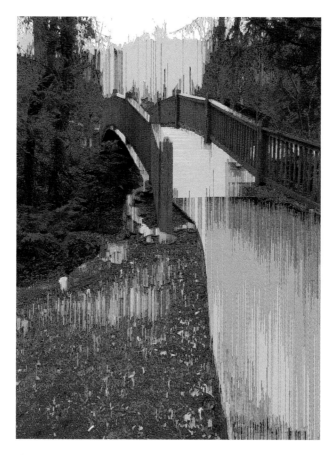

Another View of Bridge over Le Conte Creek •
Great Smoky Mountains National Park, Tennessee

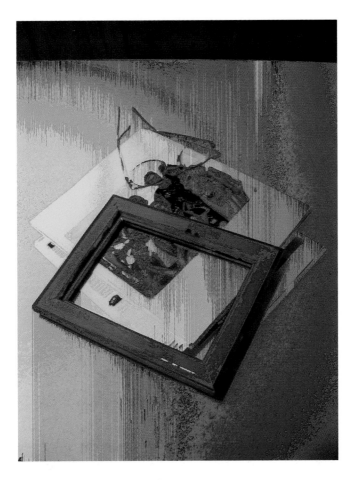

Junk on Our Kitchen Counter • *Walden, Tennessee*

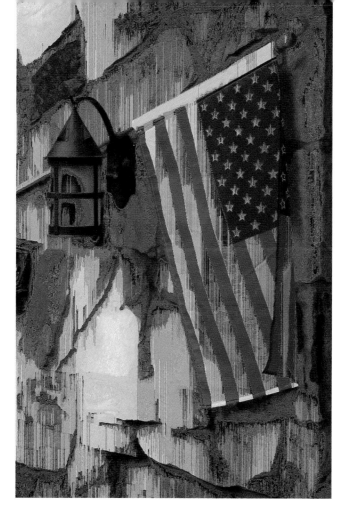

Our Flag at Home • *Walden, Tennessee*

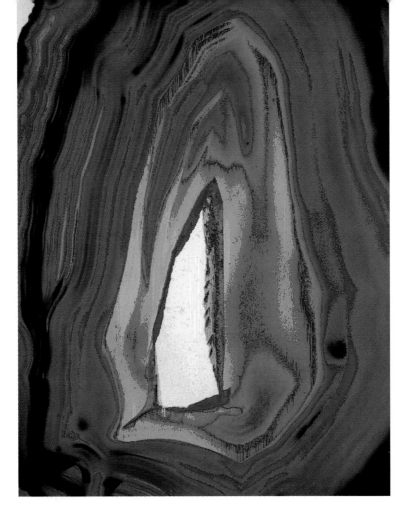

Polished Gem • *Las Vegas, New Mexico*

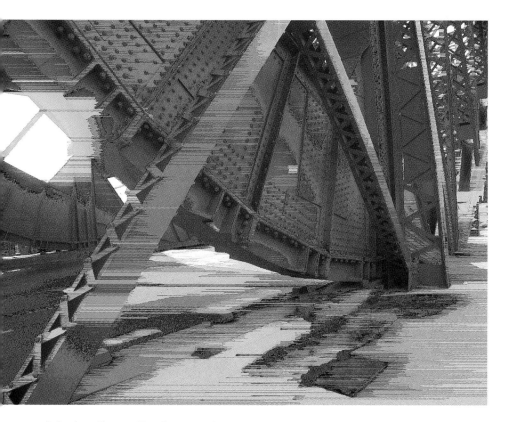

Market Street Bridge Mechanism • *Chattanooga, Tennessee*

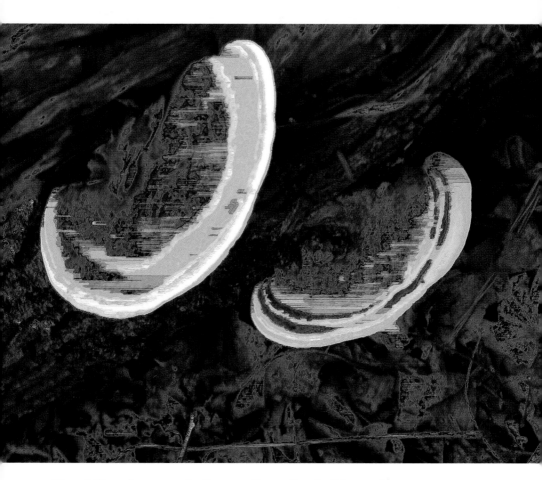

Fungi Growing out of a Log • *Great Smoky Mountains National Park, Tennessee*

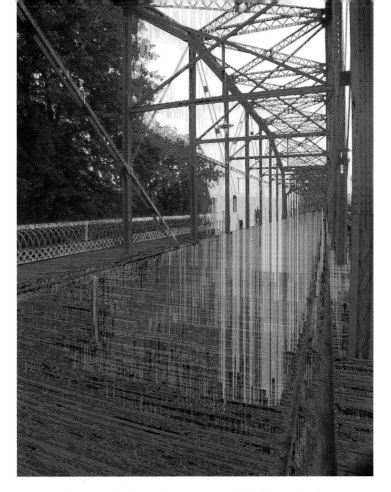

Walnut Street Bridge, the Longest Walking Bridge
in the Nation • *Chattanooga, Tennessee*

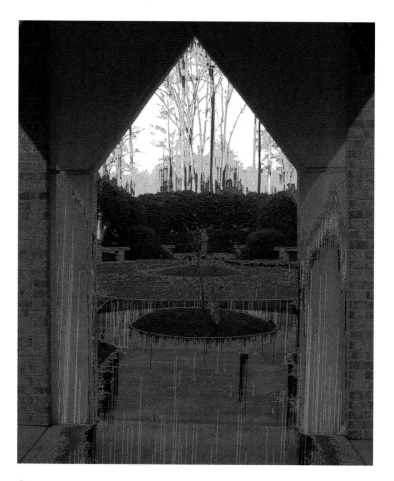

St. Martin's Episcopal Church • *Chattanooga, Tennessee*

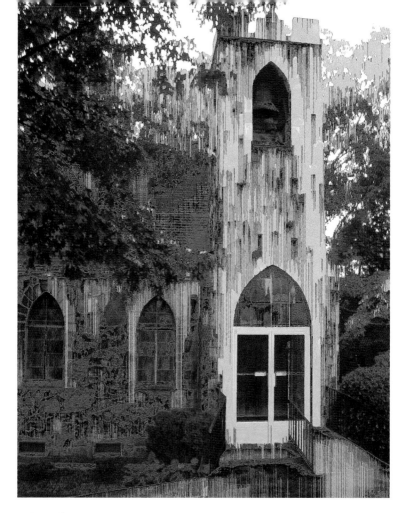

Wayside Presbyterian Church • *Walden, Tennessee*

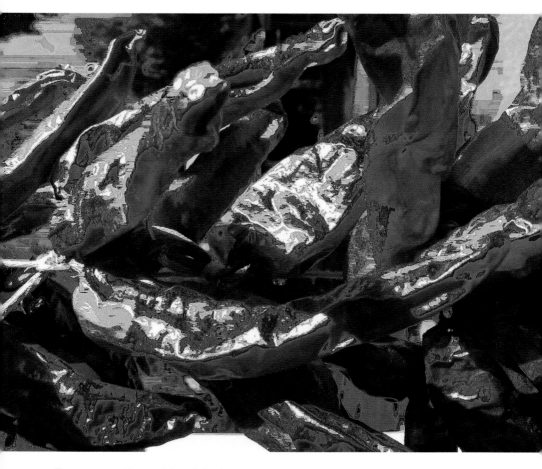

Peppers • *Pecos, New Mexico*

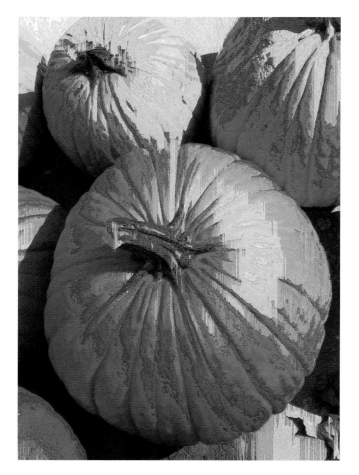

Pumpkins • *Walden, Tennessee*

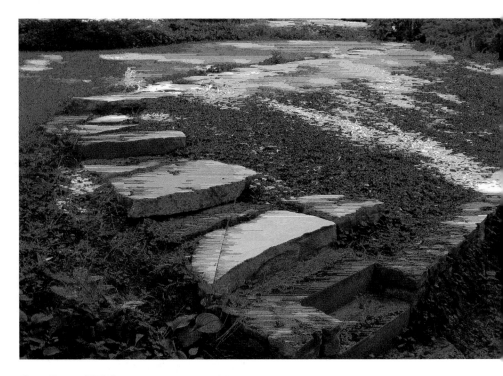

Our Stone Walkway • *Walden, Tennessee*

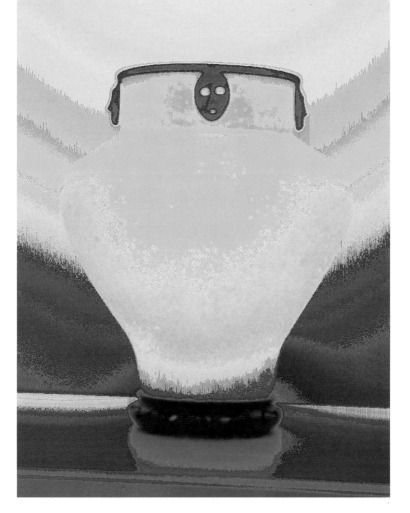

Vase, Andrews McMeel Publishing • *Kansas City, Missouri*

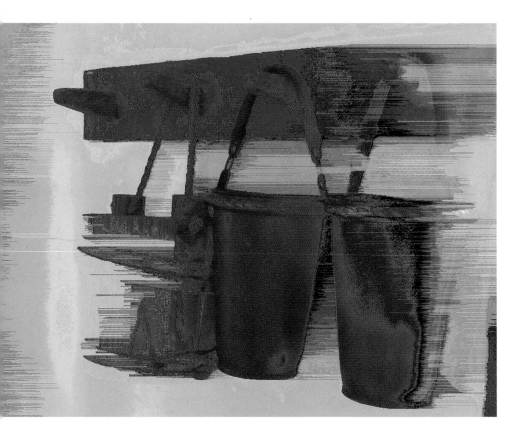

Leather Water Buckets • *Fort Scott National Historic Site, Kansas*

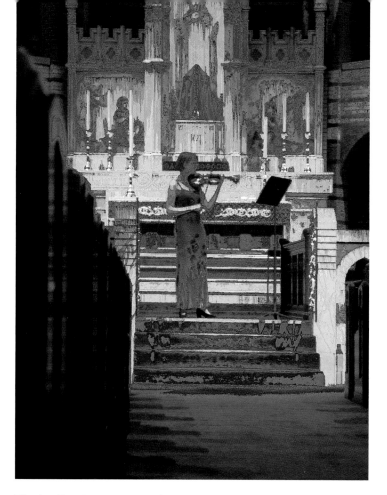

Violin Performance at St. Paul's Episcopal Church •
Chattanooga, Tennessee

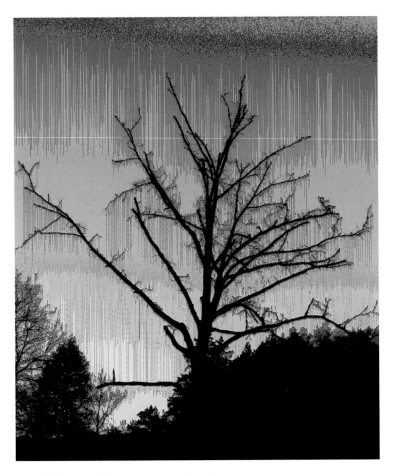

Bare Tree at Home • *Walden, Tennessee*

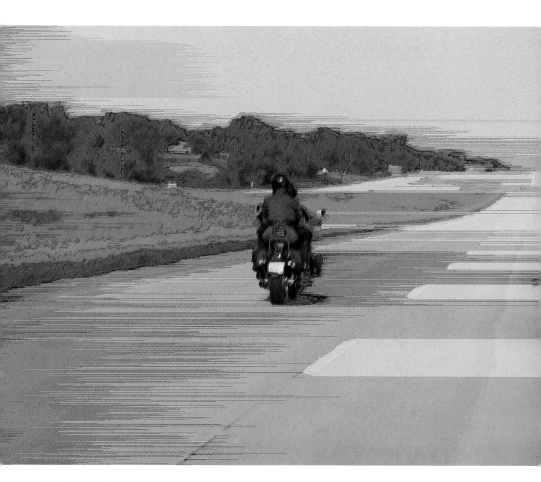

Motorcycle • *Kansas*

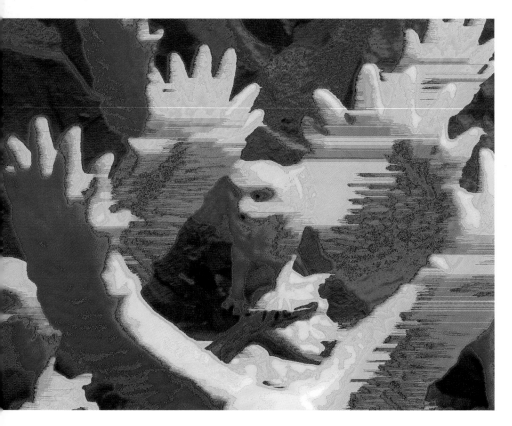

Wings of Owl Figurines • *Missouri*

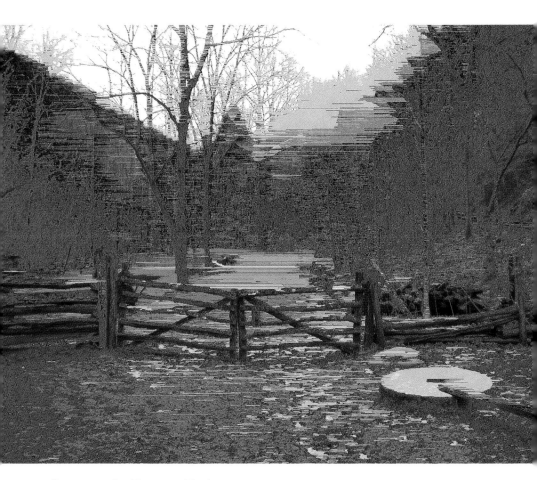

Scene on the Roaring Fork • *Great Smoky Mountains National Park, Tennessee*

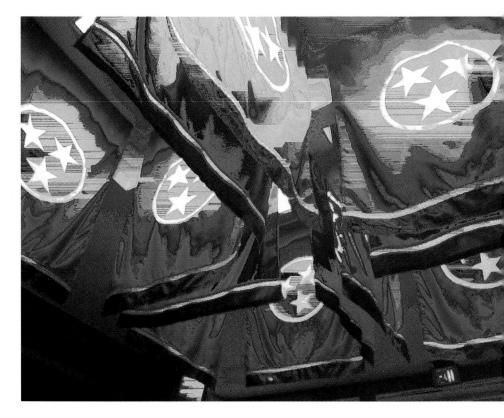

State of Tennessee Flags at the Welcome Center •
Interstate 24 East, Tennessee

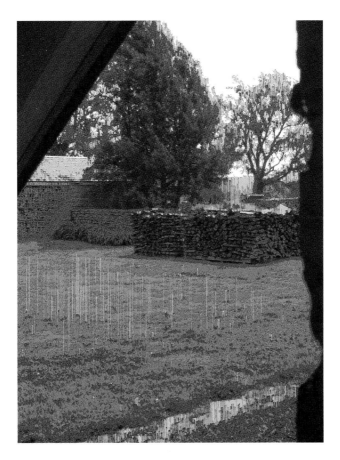

Stacked Firewood • *Fort Scott National Historic Site, Kansas*

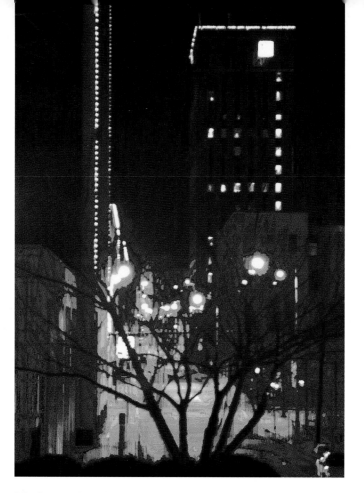

Night Lights from St. Paul's Episcopal Church •
Chattanooga, Tennessee

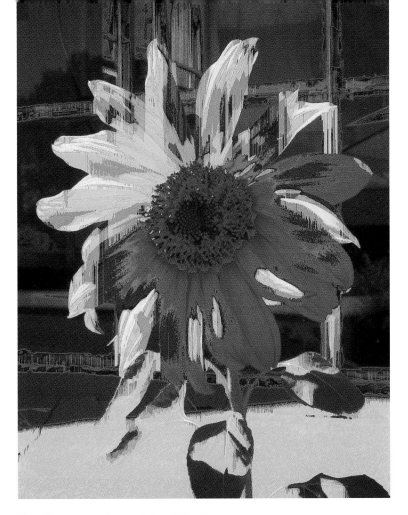

Sunflower • *Pecos, New Mexico*

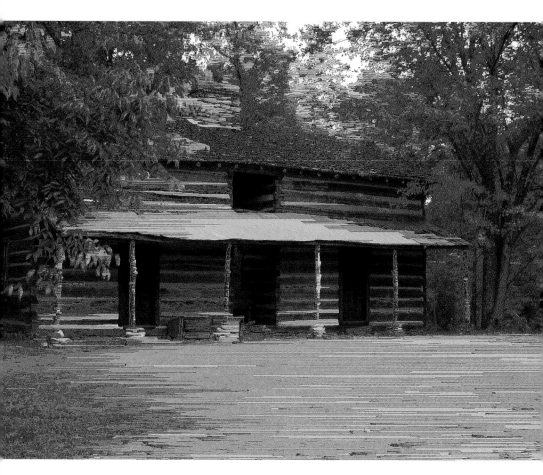

Connor Toll House • *Walden, Tennessee*

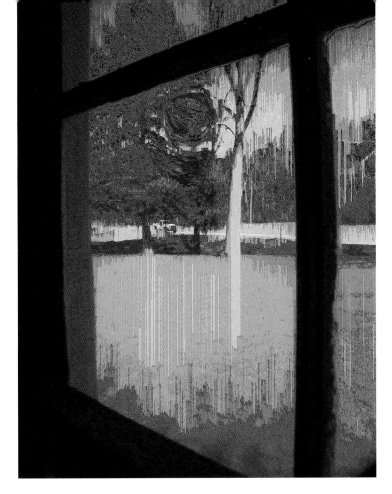

View out of Cabin Window • *Great Smoky Mountains National Park, Tennessee*

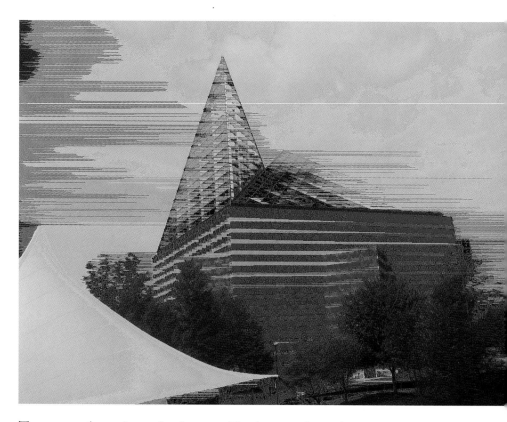

Tennessee Aquarium, the Largest Freshwater Aquarium
in the World • *Chattanooga, Tennessee*

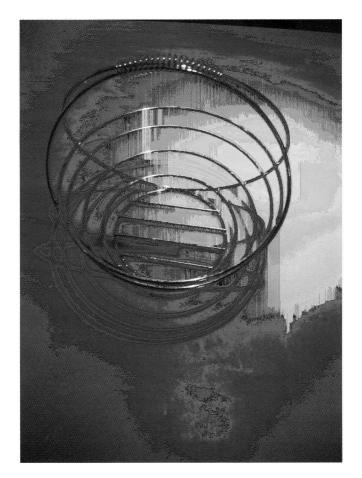

Wire Basket • *Pecos, New Mexico*

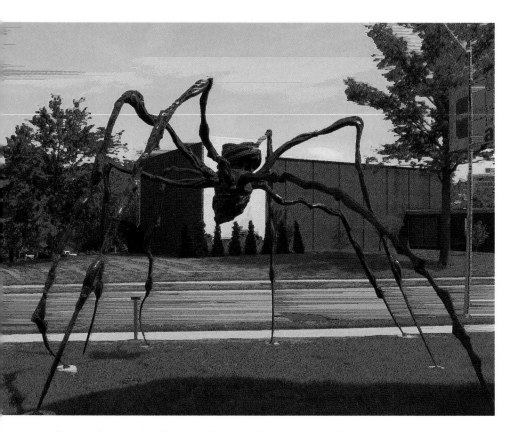

Large Spider Sculpture, Kemper Museum of Contemporary Art •
Kansas City, Missouri

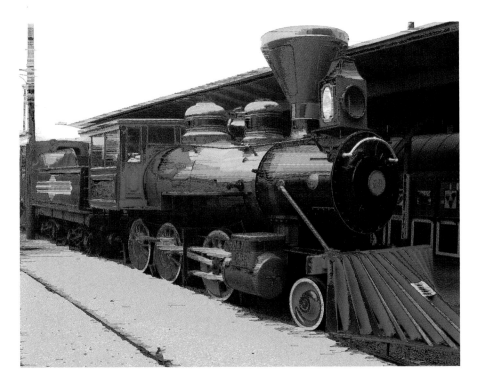

Railway Engine at Chattanooga Choo Choo • *Chattanooga, Tennessee*

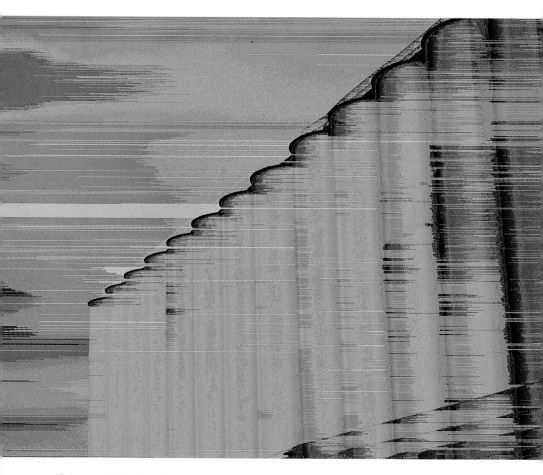

Silos • *U.S. 56, Kansas*

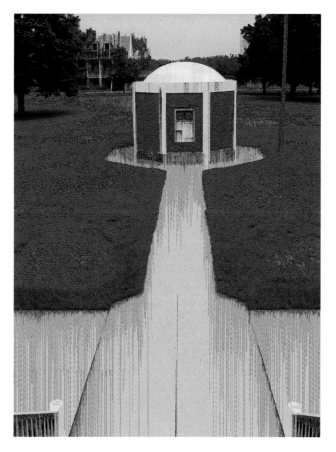

Powder Magazine • *Fort Scott National Historic Site, Kansas*

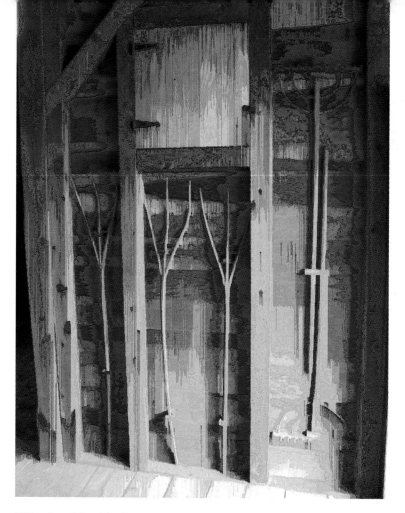

Wooden Hay Forks • *Fort Scott National Historic Site, Kansas*

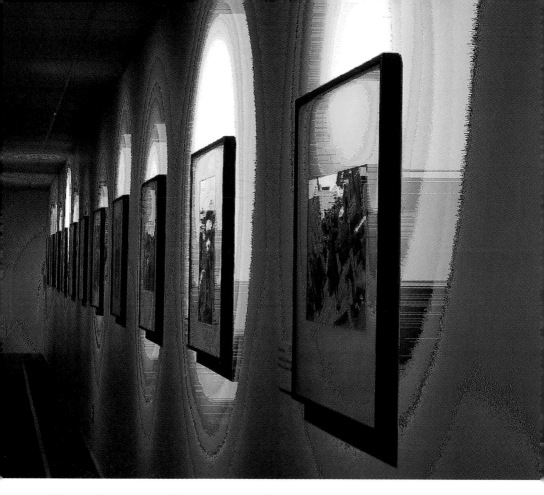

Wall of Pictures at Martin Luther King Jr. National Monument •
Atlanta, Georgia

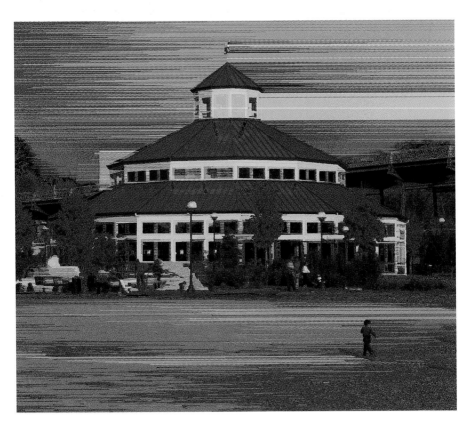

Coolidge Park Carousel • *Chattanooga, Tennessee*

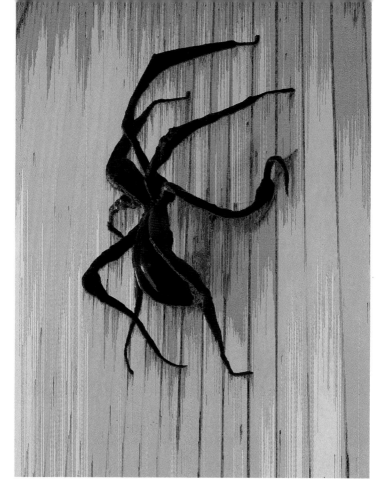

Small Spider Sculpture at Kemper Museum of
Contemporary Art • *Kansas City, Missouri*

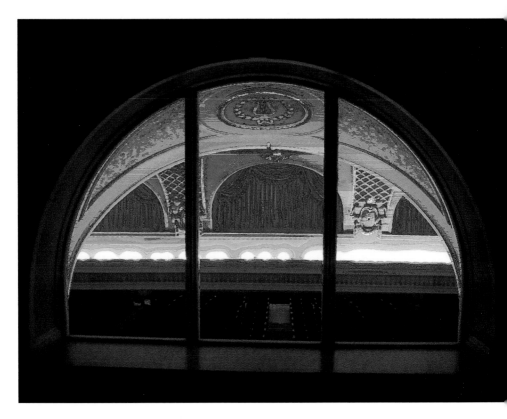

View of Tivoli Theatre Balcony • *Chattanooga, Tennessee*

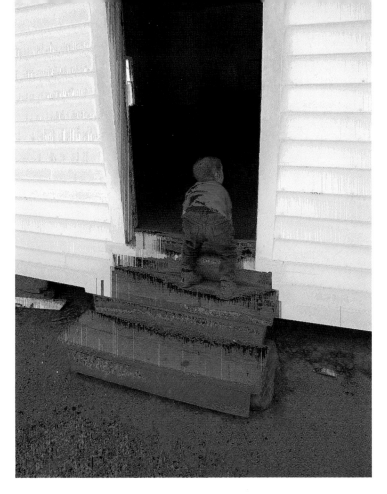

Church in Cades Cove • *Great Smoky Mountains National Park, Tennessee*

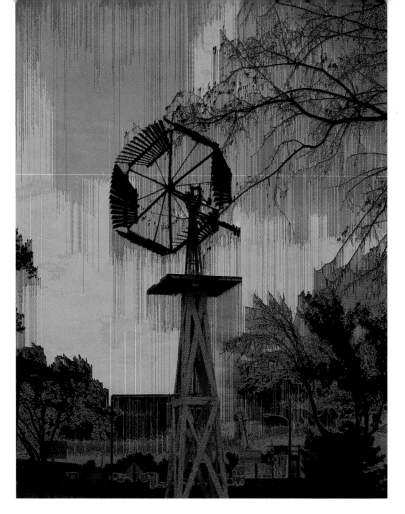

Old Windmill • *Midway, Kansas*

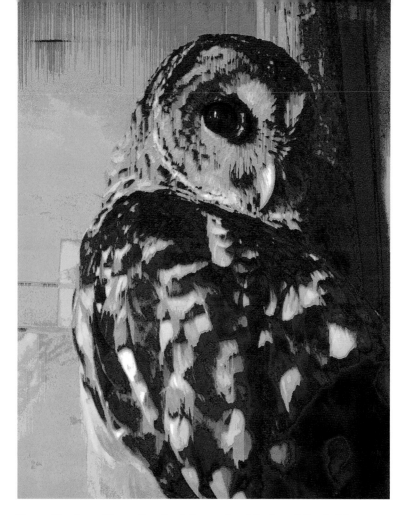

Barn Owl • *Great Smoky Mountains National Park, Tennessee*

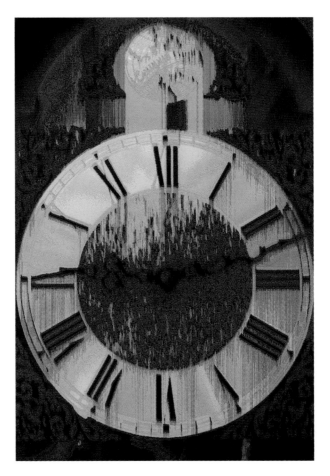

Grandfather Clock Face • *Walden, Tennessee*

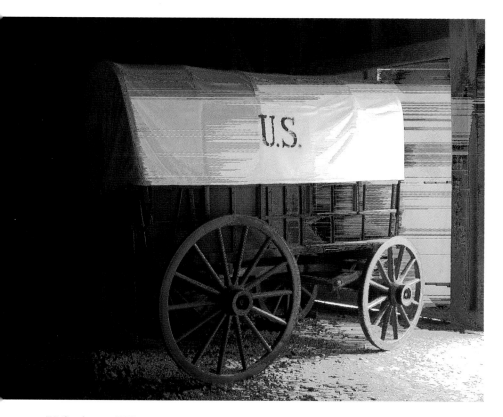

U.S. Army Wagon • *Fort Scott National Historic Site, Kansas*

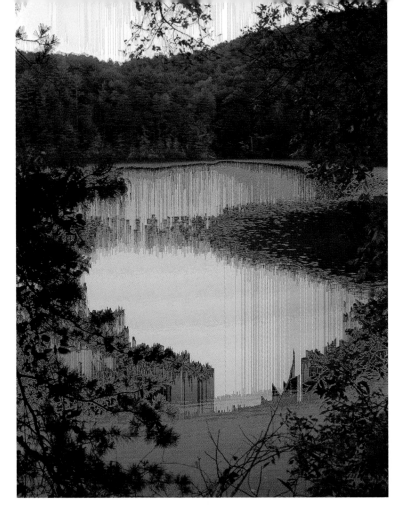

Fall Season at Parksville Lake • *Tennessee*

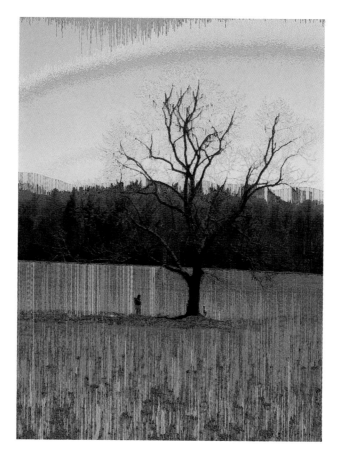

Picnickers under Tree in Cades Cove • *Great Smoky Mountains National Park, Tennessee*

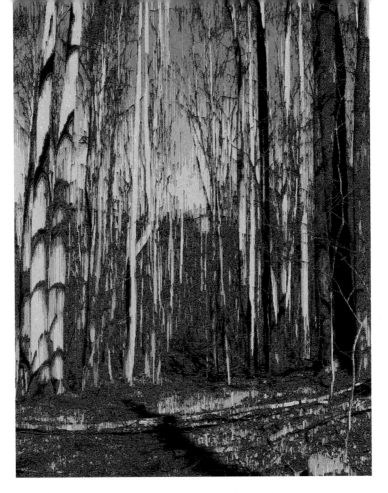

Woodland Scene • *Great Smoky Mountains National Park, Tennessee*

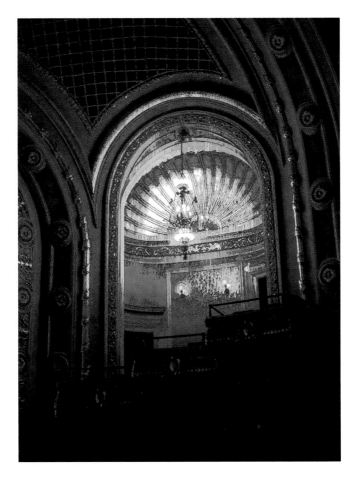

Box Seats at Tivoli Theatre • *Chattanooga, Tennessee*

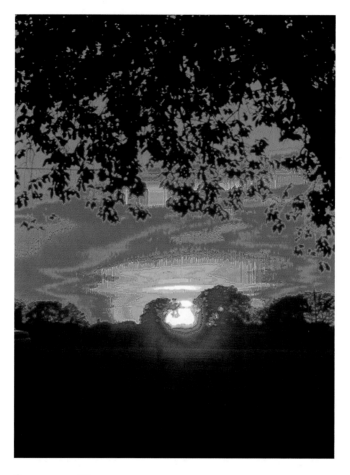

Sunset • *Kansas*

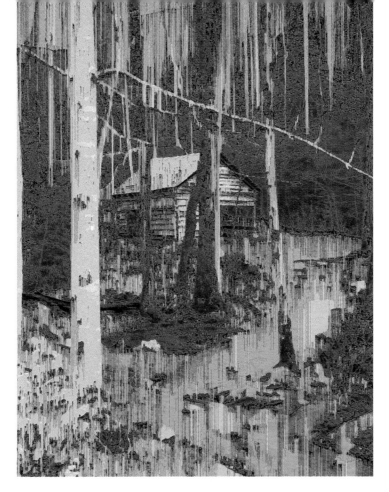

Log Barn • *Great Smoky Mountains National Park, Tennessee*

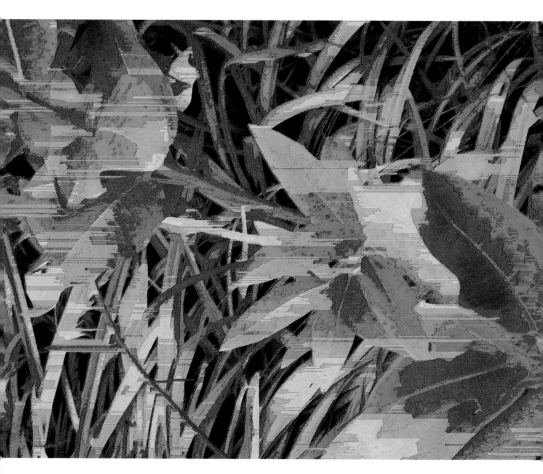

Pecos Foliage • *Pecos, New Mexico*

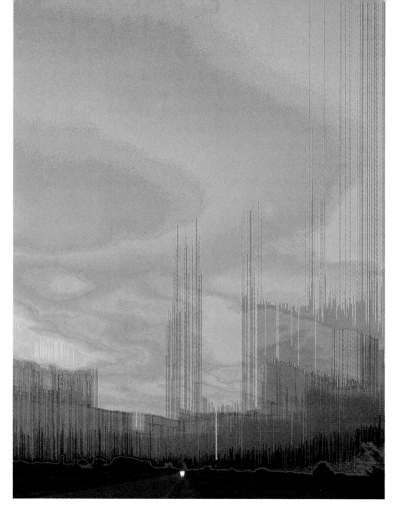

Car Approaching at Twilight • *U.S. 56, Kansas*

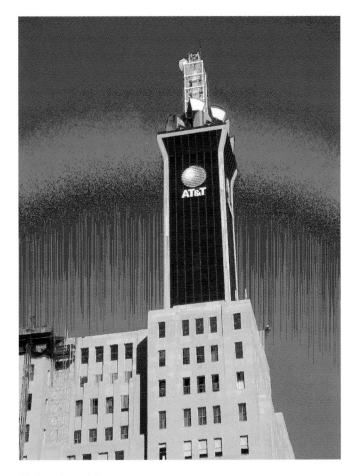

AT&T Building · *Atlanta, Georgia*

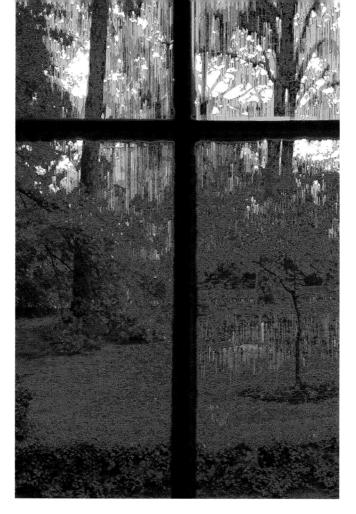

View from Our Window • *Walden, Tennessee*

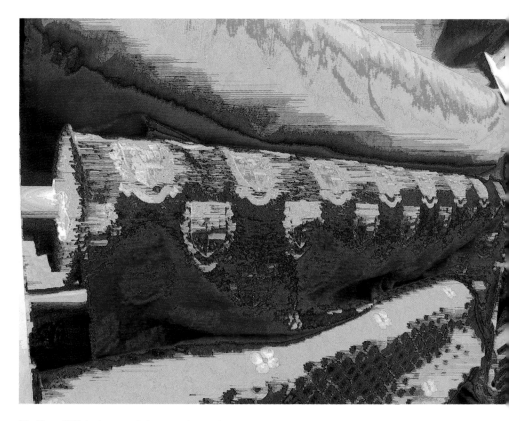

Rolls of Fabric • *Atlanta, Georgia*

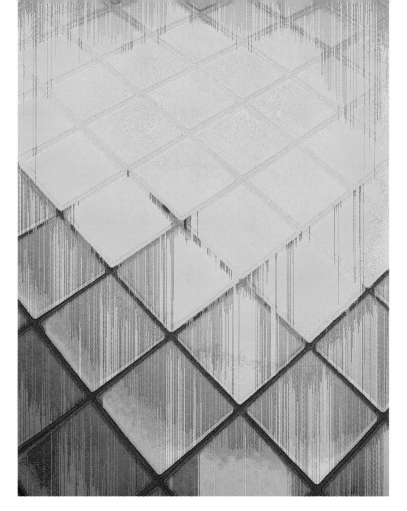

Tile Floor at McDonald's • *Signal Mountain, Tennessee*

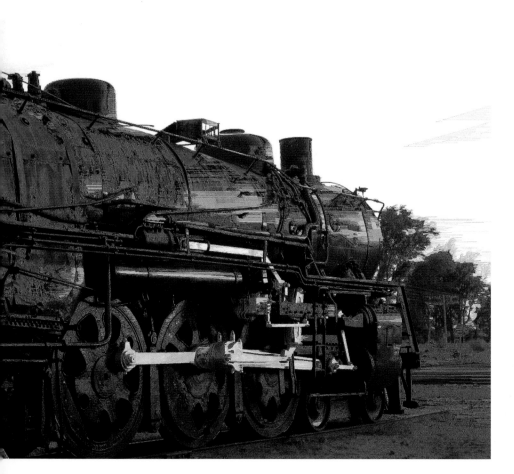

Train, End of the Line • *Midway, Kansas*

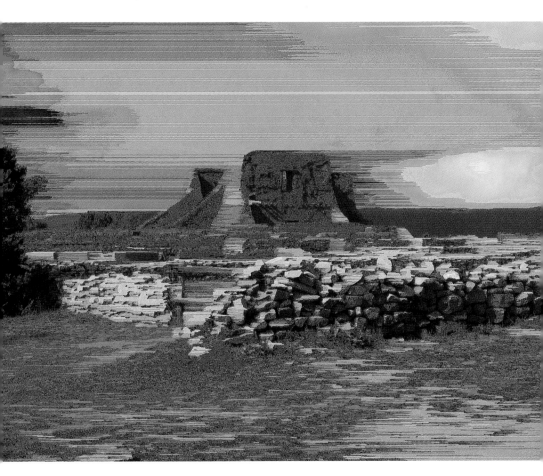

Pecos National Monument • *Pecos, New Mexico*

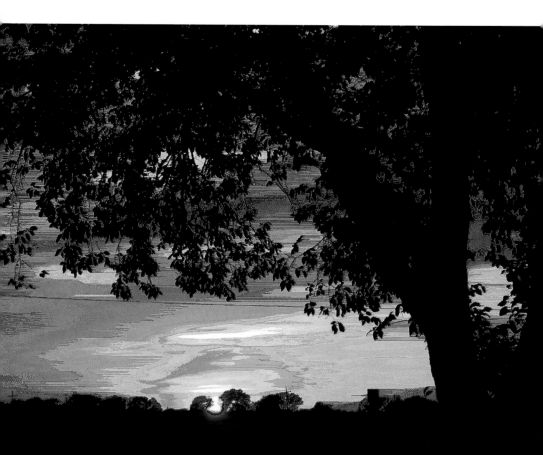

Sunset through Ancient Tree • *Midway, Kansas*

60

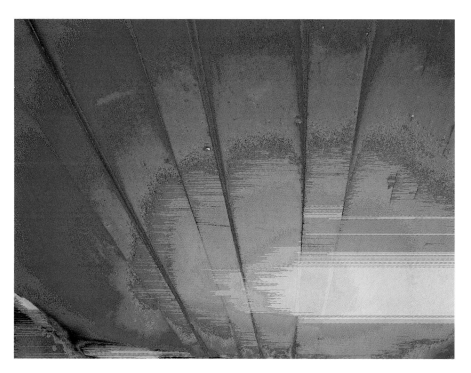

Vertical Abstract • *Chattanooga, Tennessee*

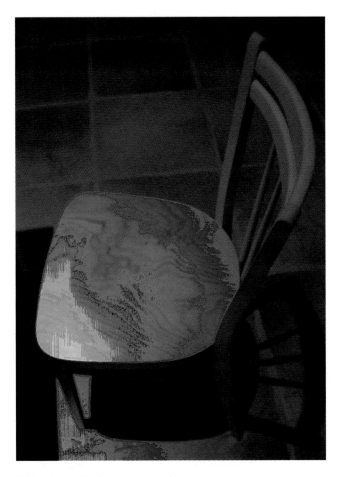

Wooden Chair • *Pecos, New Mexico*

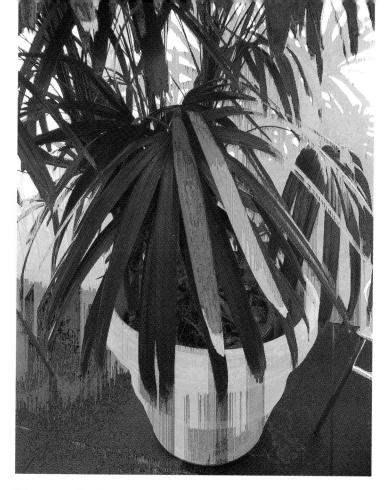

Plants at Café Sebastienne in Kemper Museum of
Contemporary Art • *Kansas City, Missouri*

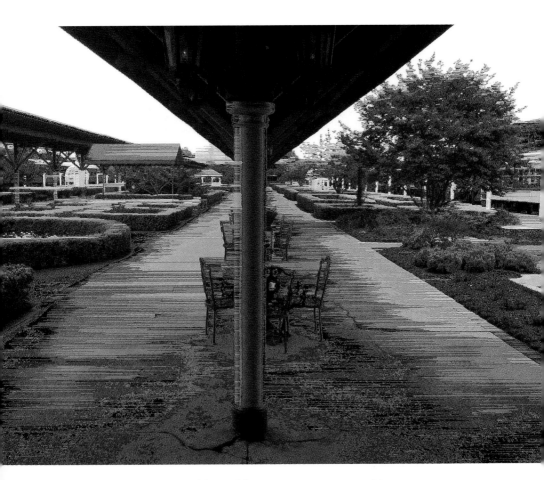

Scene at Chattanooga Choo Choo • *Chattanooga, Tennessee*

64

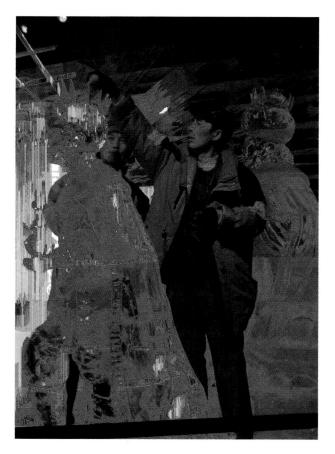

Ice Carvers at Opryland Ice Show •
Nashville, Tennessee

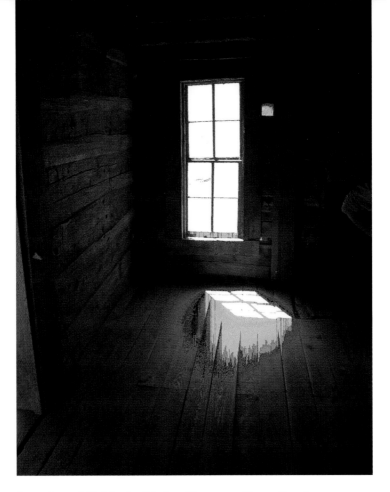

Interior of Cabin in Cades Cove • *Great Smoky Mountains National Park, Tennessee*

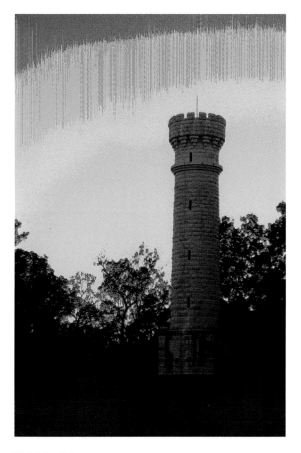

Wilder Tower • *Chickamauga National Military Park, Georgia*

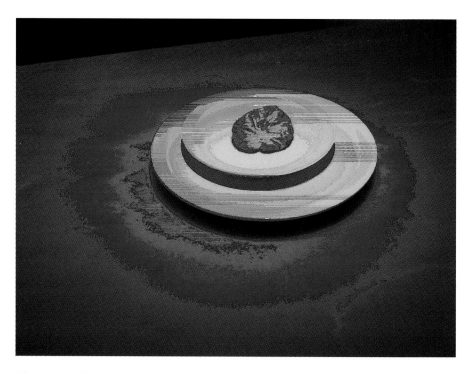

Breakfast Bun • *Pecos, New Mexico*

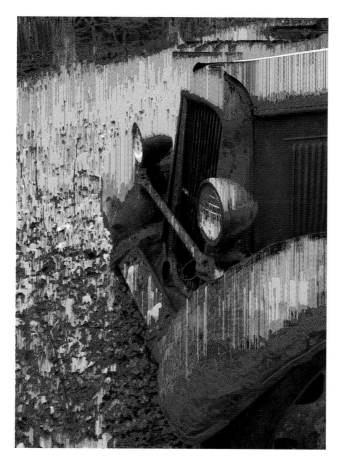

Old Truck • *Gatlinburg, Tennessee*

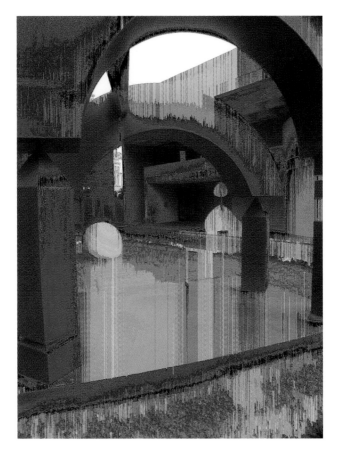

Sculpture at Hunter Museum •
Chattanooga, Tennessee

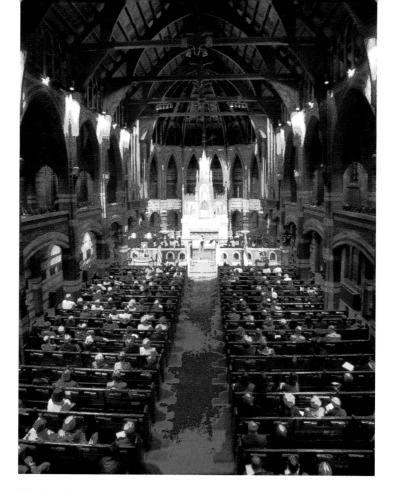

Violin Concert St. Paul's Episcopal Church •
Chattanooga, Tennessee

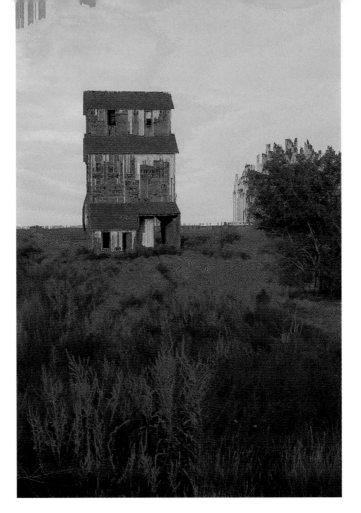

Old Grain Elevator • *U.S. 56, Kansas*

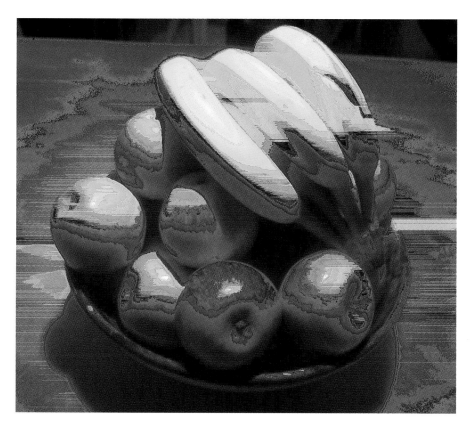

Bowl of Fruit at Pecos River Cabins • *Pecos, New Mexico*

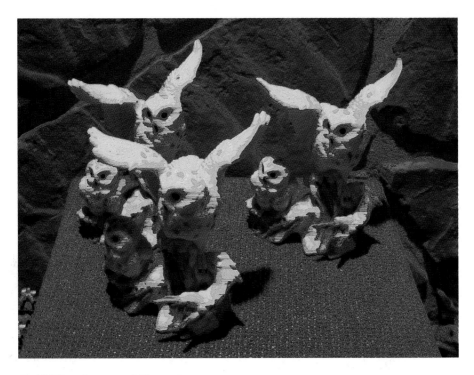

Owl Figurines • *Missouri*

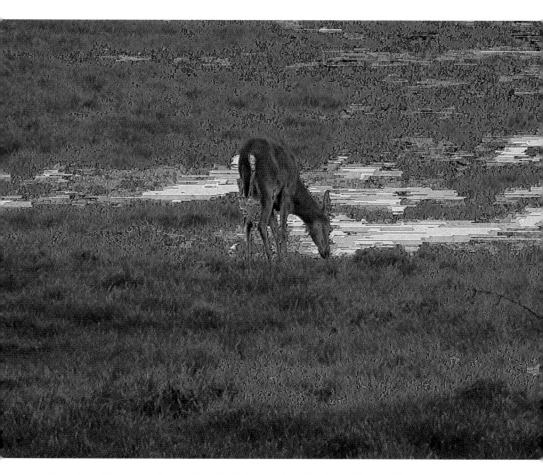

Grazing Deer • *Great Smoky Mountains National Park, Tennessee*

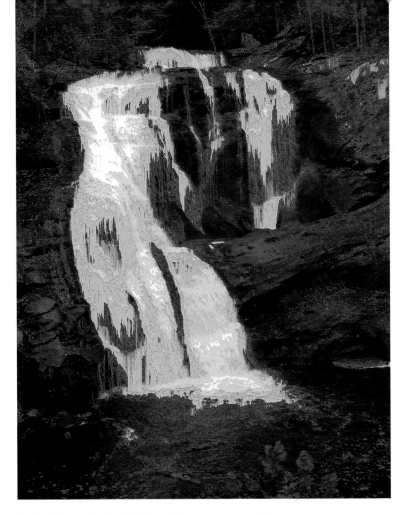

Bald River Falls, Tellico Mountains • *Tennessee*

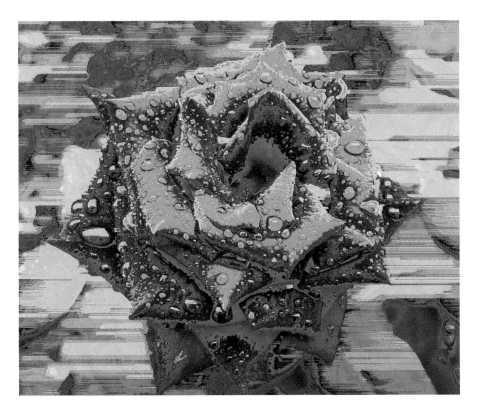

Dew-Covered Rose, Atlanta Botanical Garden • *Atlanta, Georgia*

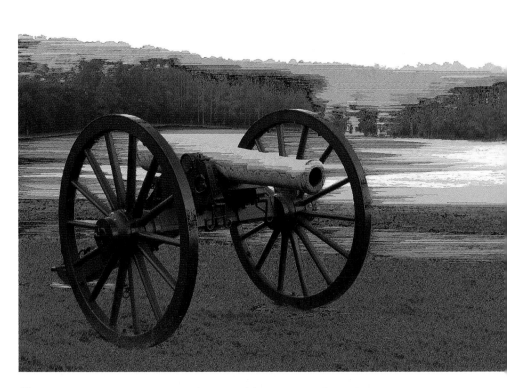

Cannon • *Chickamauga National Military Park, Georgia*

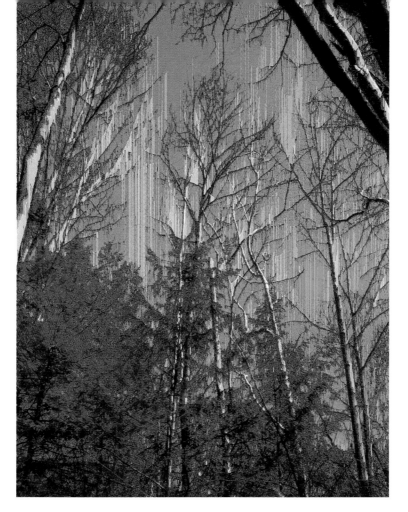

Scene from My Bathroom Window • *Walden, Tennessee*

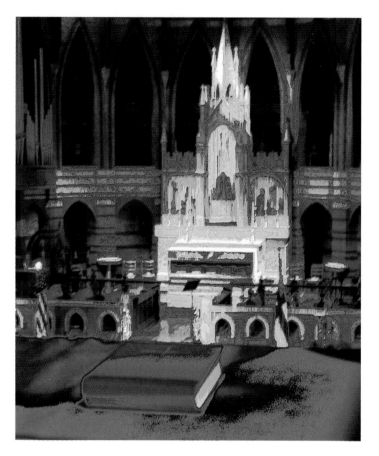

View from the Balcony of St. Paul's Episcopal Church •
Chattanooga, Tennessee

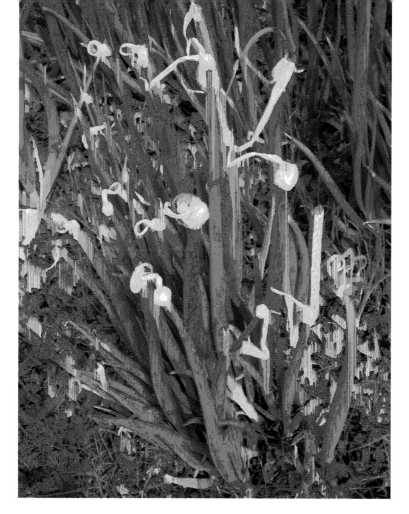

Flower Garden • *Fort Scott National Historic Site, Kansas*

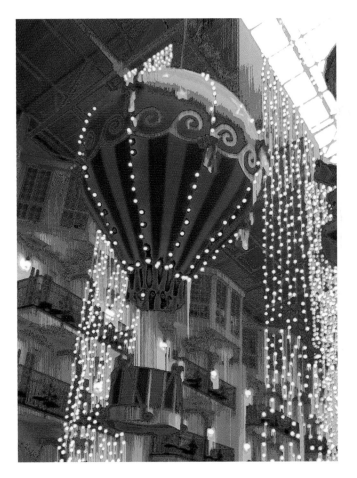

Christmas at Opryland Hotel • *Nashville, Tennessee*

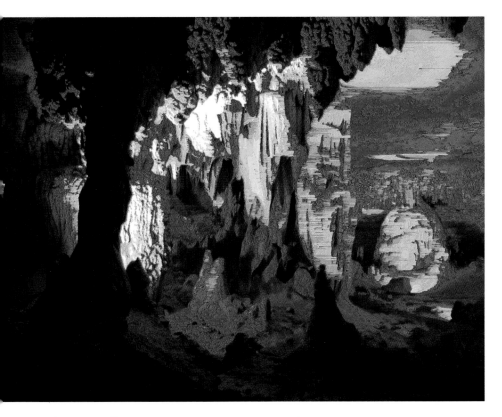

Fantastic Caverns • *Springfield, Missouri*

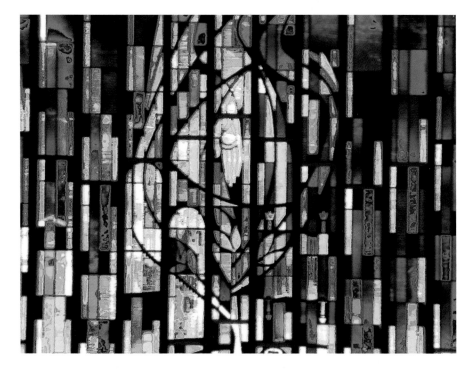

Stained Glass at Signal Crest United Methodist Church • *Signal Mountain, Tennessee*

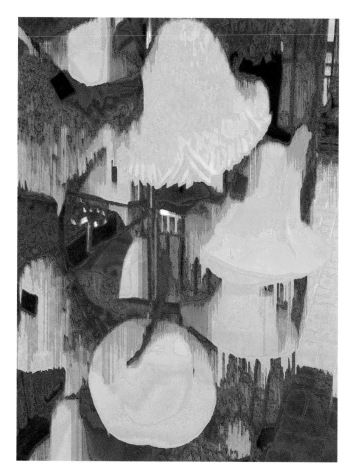

Straw Hats • *Springfield, Missouri*

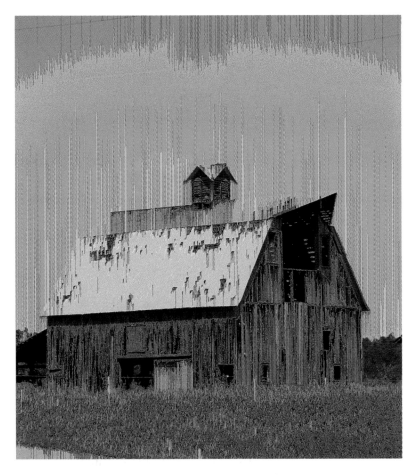

Old Barn • *U.S. 56, Kansas*

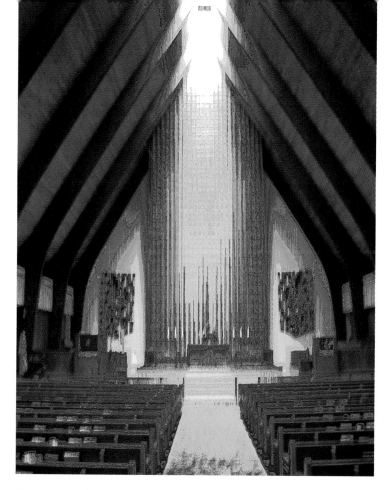

Sanctuary, Signal Crest United Methodist Church •
Signal Mountain, Tennessee